Everyday Things

Everyday Things

Photographs by Neil Winokur

Smithsonian Institution Press, Washington and London
Published in association with Constance Sullivan Editions

This series was developed and produced for the Smithsonian Institution Press
by Constance Sullivan Editions

Series editor:
Constance Sullivan

Smithsonian editor:
Amy Pastan

Designed by Katy Homans

Library of Congress Cataloging-in-Publication Data

Winokur, Neil.
 Everyday Things / photographs by Neil Winokur. —1st ed.
 p. cm. — (Photographers at work)
 "Published in association with Constance Sullivan Editions."
 ISBN 1-56098-43-9 (pbk.)
 1. Photography, Artistic. 2. Winokur, Neil. I. Title. II. Series.
 TR654.W555 1994
 779'.9092—dc20 93-47977
 CIP

Thanks to Janet Borden and Matthew Wentworth for their help in preparing this book.

First edition

Printed by Meridian Printing, East Greenwich, RI, USA

Cover: Wally, 1992

After experimenting with black-and-white street photography early on, what made you settle on color portraiture?

I've always loved portraits. I love Berenice Abbott portraits. I love August Sander portraits. I don't like landscapes very much. I think they're pretty, and it's not that nature leaves me cold or anything, but I think the reality is usually far nicer than any kind of picture of it. And these days people often do urban landscapes anyway so the reality is probably far worse than the pictures. But I've just always loved to look at portraits. I like to look at old family photographs, even if I don't know the people, because you're getting a feeling of how they lived. You're seeing history.

But a lot of old photographs don't really give you much history, like the studio portrait or the graduation head shot, which is more similar to your work.

The graduation headshot or the police mugshot or my photos—they're all the same thing. It's basically, this is what the person looks like. I will tell you nothing about them. You can make up your own story about this person, because that's all the information you really have. Any other information I supply might or might not be real. I can't fake the way their head looks. But if I change their clothes and put them in a fancy office or give them a hoe and put them on a farm, then I'm telling you what they do. Which I think is valid. That's what real portraits should do. I was trying to make two points: One, that portraits—no matter how much information they seem to give—don't necessarily reveal anything about the person. Two, the color—this bright background that makes you really look at it, and not think of the person. Almost anybody can be a star. Someone's going to look at the picture and say, Who *is* that person? Like Andy Warhol's idea that everyone's famous for fifteen minutes, I was doing it for five seconds.

How did the portrait series get under way?

I was always pretty shy, and I thought if I forced myself to do portraits, I'd have to talk to people and it would be a way to come out of this shyness. Only that actually didn't work too well because I took pictures of friends so it was fairly easy. But I also figured, I know a lot of people

in the art world and all my friends are artists of some sort, so I might as well document them, be their court photographer in a way. From the beginning I knew there was something weird about my portraits, that they wouldn't quite go over as everyday magazine-type portraits. I don't really know what it is—I think a lot of it is the color and the fact that they're life-sized head shots, and actually if you look at them in an 8x10 size they don't look so strange.

Were they always these straightforward head shots?

When I first started, my influence was the Hollywood glamour portrait. Some were straight-on but most were supposed to be more glamorous, sort of looking away. The basic premise behind the portraits was—this was a period when I used to go to bars a lot, everybody used to go and hang out. People were decked to the nines, all dressed up. And you'd learn nothing about them. Some guy could be a banker during the day and a hippie at night. The person who looks like a derelict might be John Paul Getty III—it's all about façades. So I thought if I did these very Pop head shots, they wouldn't show anything. The color background makes the person stand out. These photographs reveal every detail while telling you nothing about the person except what they present to the camera.

You weren't going for a psychological portrait?

Definitely not. Because I had the feeling that there was no such thing as a psychological portrait. Portraits don't really tell you anything about the person other than what they might want you to think. Portraits are one more façade, so I'll show that façade. Also, these portraits became very confrontational. Sitting on a stool in front of a 4x5 camera with two huge strobes in front of you, is not a very relaxing atmosphere. First of all, people have to be pretty strong to even do it. Weak people just crumple up. Artists and people who are used to having their picture taken do fine. You have to be tough; you have to fight back, which wasn't a problem with most of the people I photographed. I was often the weaker of the two. But it isn't a relaxing process, or a flattering process, necessarily.

**Do you feel that those kind of portraits are not
valid anymore or just impossible?**

No, they're still valid, but basically they aren't what I want to do, at least
not all of the time. I want to try different things and not be limited to
doing only portraits. There's nothing wrong with doing just portraits.
Brassai mainly did portraits and Man Ray is one of my favorite photo-
graphers and his portraits are wonderful (of course, Man Ray did lots of
other things). Right now I wish I did just portraits because it's harder to
think of a new project each year or some new way of doing things.

**What made you decide to add objects to your
pictures of people? Was it an attempt to provide
more psychological information?**

I felt like I had gone as far as I could go with the head shot portraits.
And I could just keep doing this and *be* the court photographer docu-
menting all these people or do something a little different. I first added
objects to the portraits in works I called totems. They were made up
of anywhere from five to seven photographs, one was always a portrait
and another an object that had to do with what that person did. For a
painter it was one of their paintings; if it was a writer, it could be one
of their books or a pen; and a musician, like John Hassell, had his
trumpet. The other photographs were just personal objects and it was
pretty much up to the person what the object meant, as long as it gave
some feeling about them.

Were the pictures more revealing?

I discovered pretty quickly that this was also an illusion because it
would depend on how personal the objects were that people chose.
Some people put in very personal things, but others didn't want to
reveal themselves. So again, it could be a façade, or real; you never
really knew which.

7

Do you think of your photographs of people surrounded by their possessions as indictments of consumer society?

I like objects. They don't have to be valuable objects. It's not about consumerism. When I ask people to put their favorite things into a picture, I'm not suggesting they pick the watch or a carpet that they would like to have. I photographed two people who said they didn't collect things, so they went out and borrowed things that they would have collected if they could and put those in as their objects.

You once compared yourself to the photographer Paul Outerbridge. You said, "If there's anybody that I might be like, it would be him."

Probably because of the weirdness and color of his work. But, what Outerbridge is really known for are those little black-and-white photographs of objects—he used to work in advertising. They are so beautiful. I love photographing objects. I like the idea that I can take a picture of this tape recorder, and it's a nice tape recorder, but in twenty years, it will be obsolete. So I take a picture of what might seem like a dumb object, but it's almost like taking a picture of a person and giving them their five seconds of fame, except I'm taking a picture of a coffee cup and that's just as important.

Outerbridge had a sort of clinical approach to objects and people—not trying to make them glamorous—that seems very similar to yours.

When I photographed Andy Warhol, his one comment on seeing the picture was, "Aren't you going to airbrush it?" Someone else might ask, "Aren't you going to use a soft-focus lens?" There are ways to take pictures of people and of objects so that you can make them look very soft or very glamorous. I'd rather take things the way they are. Sometimes they end up looking seductive, which isn't my intention. Like that globe, where the light sort of flows off it and it's really beautiful.

8

When you started doing objects, they were always as adjuncts to the portraits. What drew you to doing objects on their own?

I don't do that very much. I did a series of big objects, which were the only pictures I ever did where the objects didn't belong to someone. But they are supposed to be society's objects—archetypal objects.

But seen in the context of this book, separated from your self-portrait or from someone else's possessions, these pictures really stand on their own.

Well, they should. What I noticed when I did my self-portrait in objects was people would come in and say, "Gee, I had a globe just like that. I used to use that Butch Wax on my hair." Other than a few personal portraits like my parents' wedding picture, a lot of these things could have been part of anybody's life who grew up in that period. Obviously they would have had different friends, or different pets, they might have taken different drugs, or read different books. But out of forty objects, probably fifteen or twenty could have fit a lot of people.

Do you think of the objects, especially when they're seen as individual pictures, from a Pop Art perspective, as the glorified common object?

Definitely. Each of these objects can be seen as an icon—and some of them really are. In a hundred years people will be collecting these dumb things. And other objects will be forgotten, but who am I to judge right now which ones?

Was there a particular inspiration for your dog pictures?

I had done the self-portrait project and was trying to think of something new. Coming up with new projects is always my most miserable time. It usually involves several months of intense thinking, getting ideas and discarding them, then something pops into my head that never occurred to me before. Trying to think of ideas is like trying to find a girlfriend or a

boyfriend: you never find them when you're looking. For years, I had two pictures hanging above my dining room table—Clara, my dealer Janet Borden's dog, and my cat Zorba. And I was sitting on the couch with the light low and staring at the dog and thinking that a lot of people I know have dogs. I know people who have dogs instead of lovers, and dogs instead of companions, and dogs instead of children. Dogs really mean a lot to people, and dogs have moved out of their old role as workers and taken on all these new roles. And for some reason, just sitting there looking at this picture of the dog in the soft light, I started thinking, this dog should be really big. It's too small to tell the story. So I decided to photograph just dogs because they are so important. Dogs are almost like people: they come in all shapes and sizes, they have different personalities, and they're glamorous or they're smiling or they're nasty.

They also have a sense of portraiture very much like your headshots.

It was very important that they look like my portraits and objects. And in a way, it was exactly the same thing. One nice thing about making portraits of people is that you have to talk to them and get to know them. When I photograph a dog I get to know the owner, and it's sort of better because although they are nervous that their dog won't pose, they are far less nervous than if they were posing themselves. And you really see these people as parents. They are really concerned. Oh, will the dog pose. Or: *I* know how to get it to pose. Or: Let me just give it a treat. Don't give it too much candy, it'll get hyper. Just like kids. You have all the same problems as photographing people. I like dogs and it's fun photographing them—actually it's a lot easier than photographing people. You have to get people to forget whatever they're thinking about so they can sit for the picture. With dogs, you don't have to know what they're thinking about and they never complain about the way that their photograph looks.

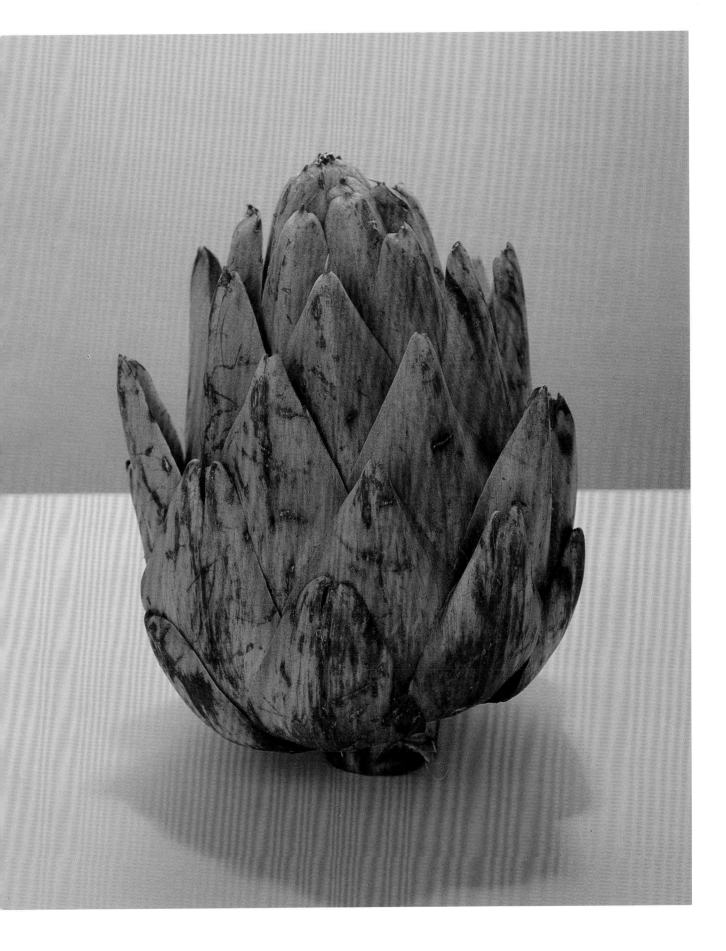

Globe, 1990

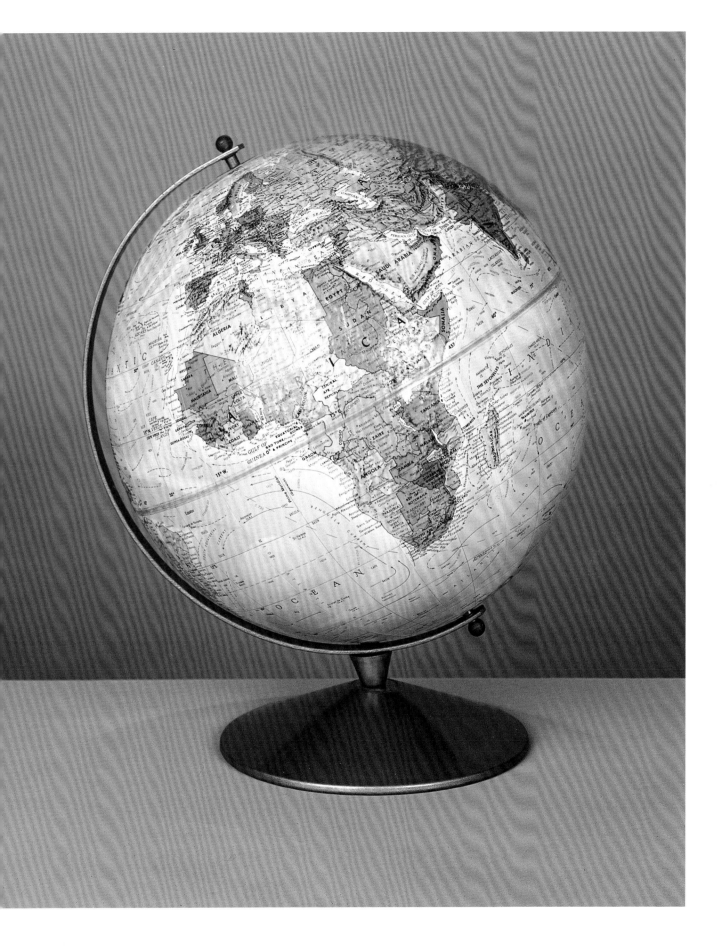

Romeo, 1992

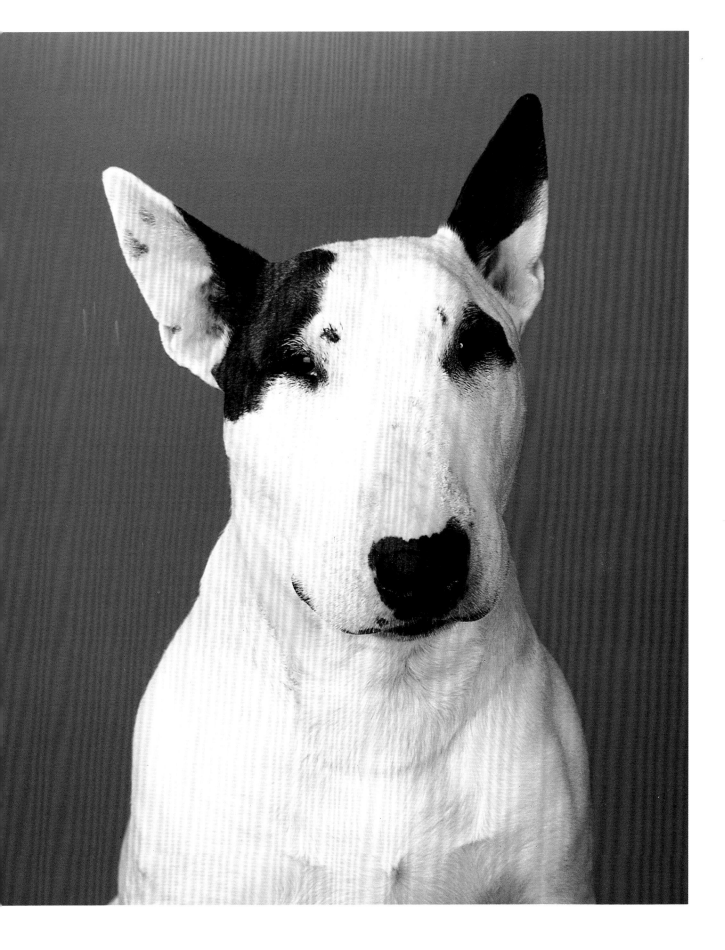

Shoe, 1990

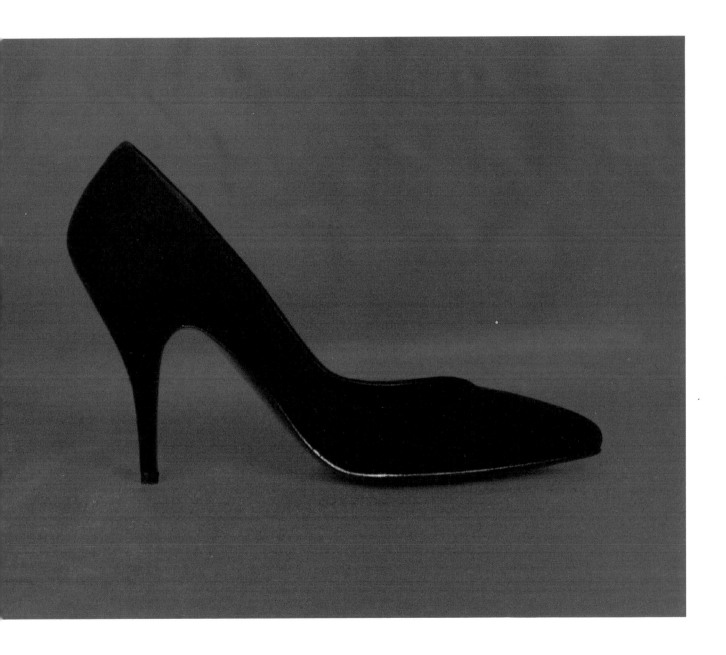

Andy Warhol, 1982

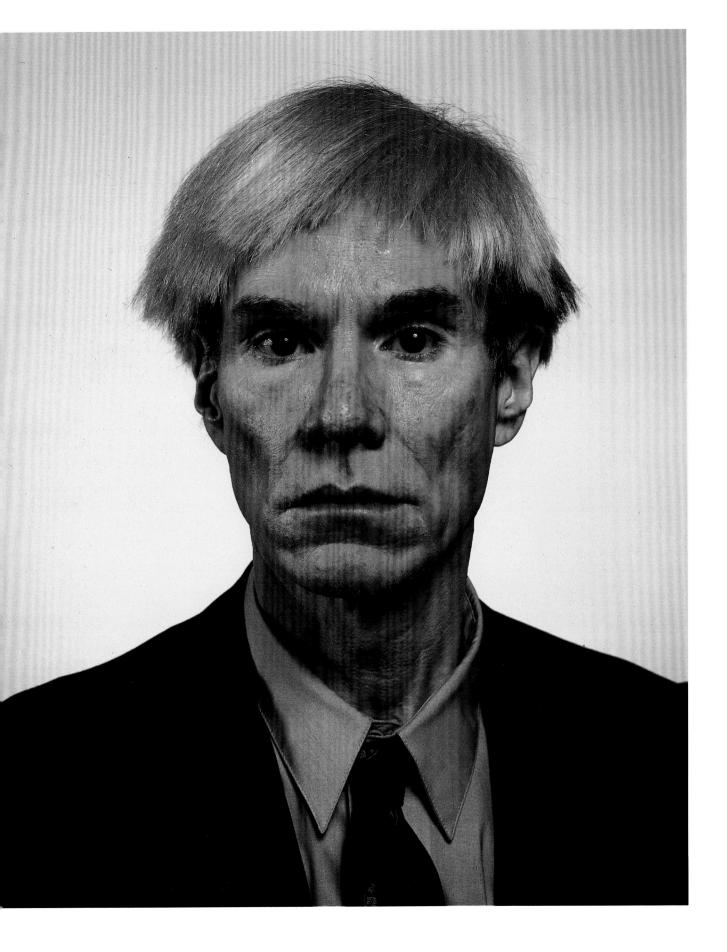

Corn, 1992

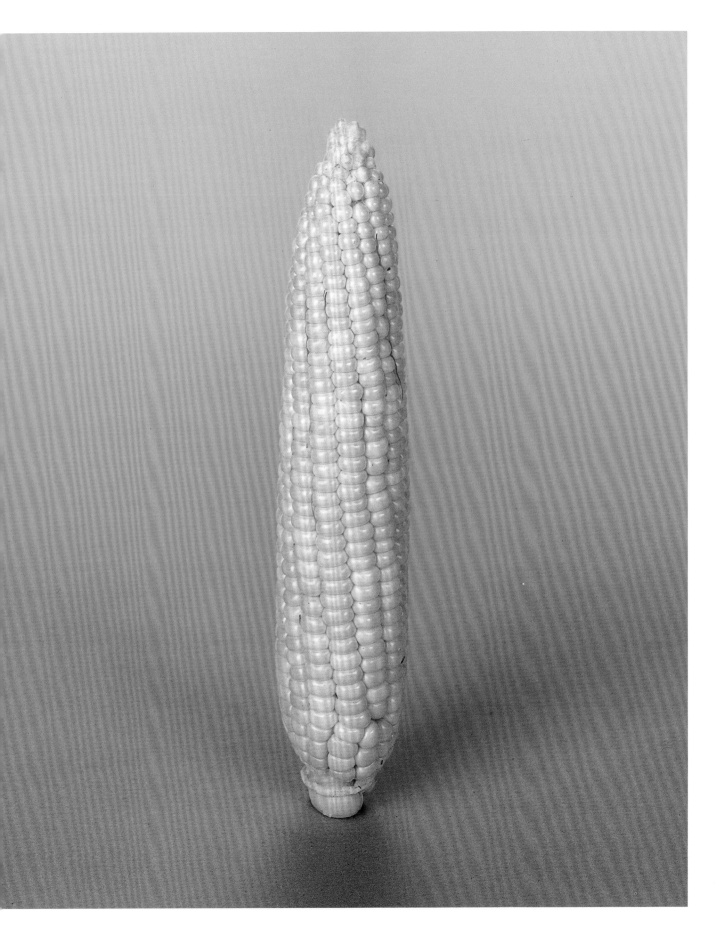

Toy Gun, 1990

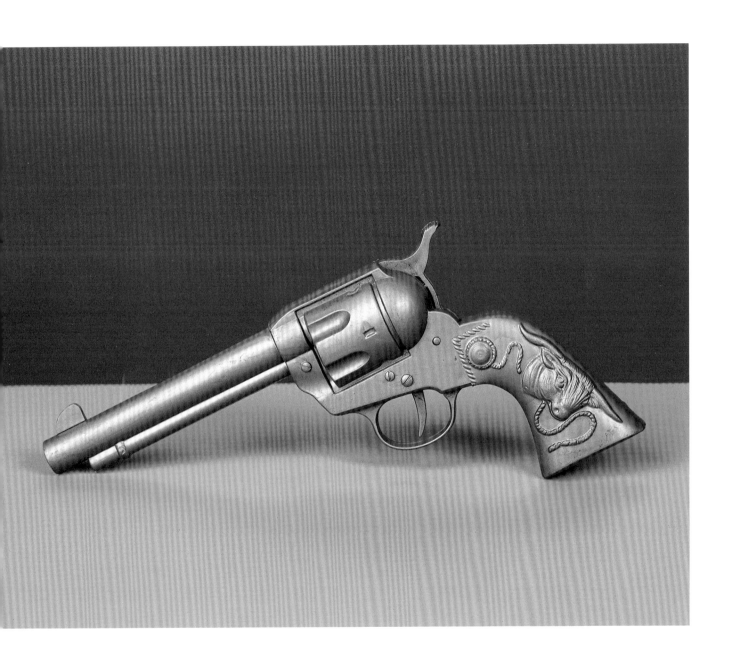

Doc, 1992

following pages: Tweeney, 1990; Clara the Baby, 1986

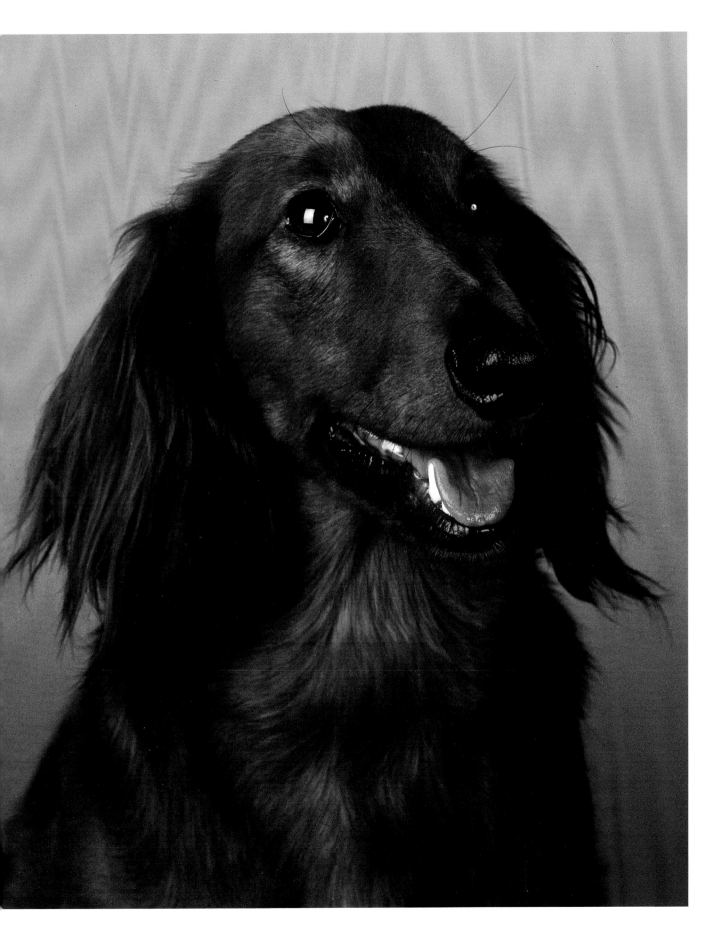

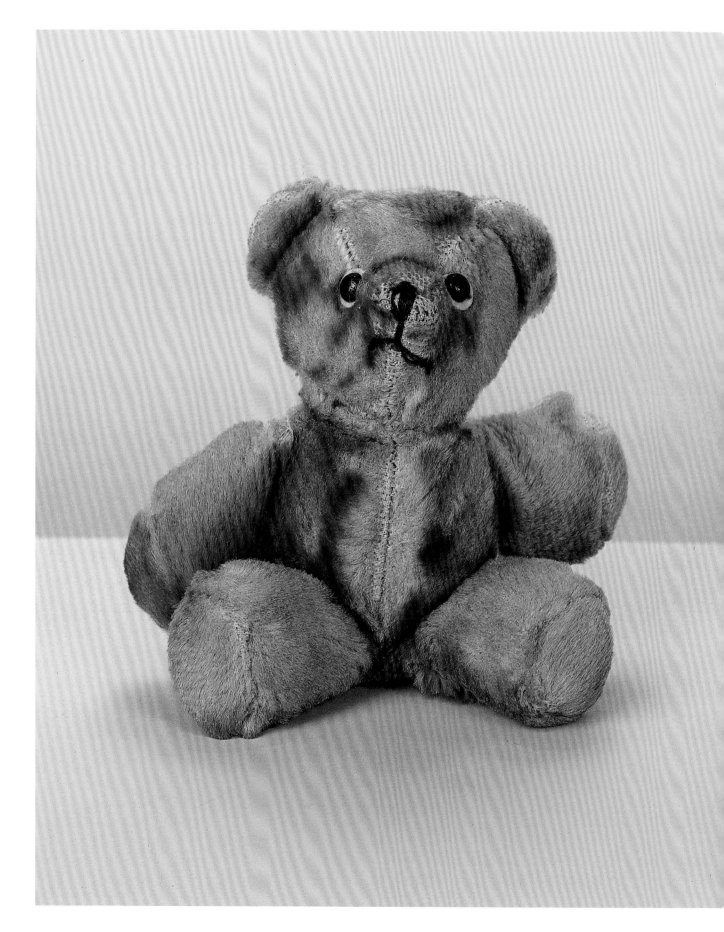

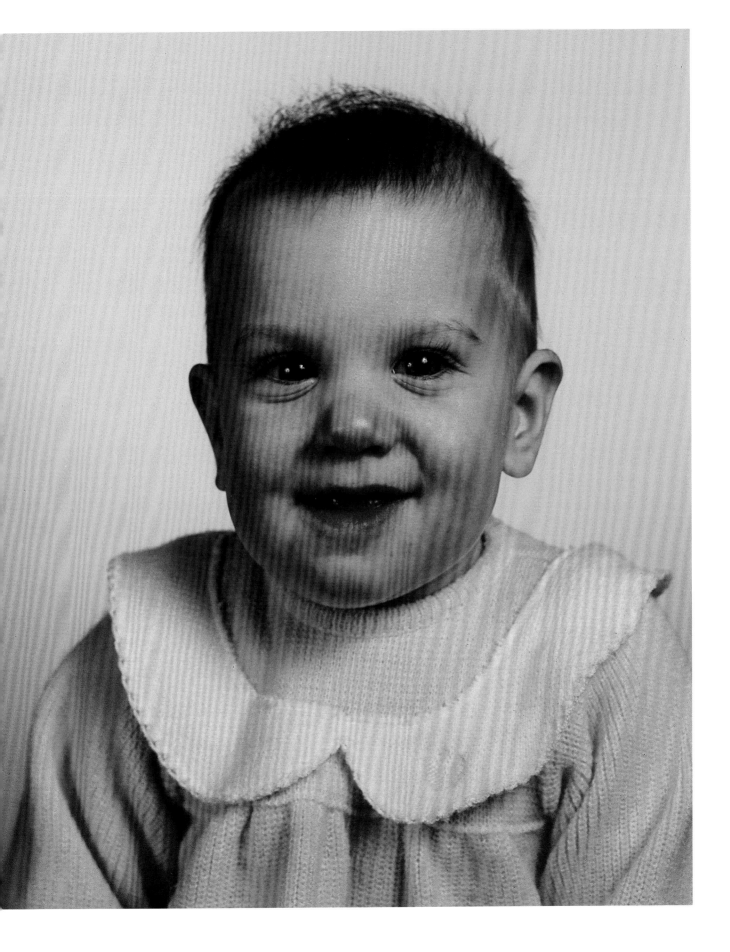

Cosmo, 1992

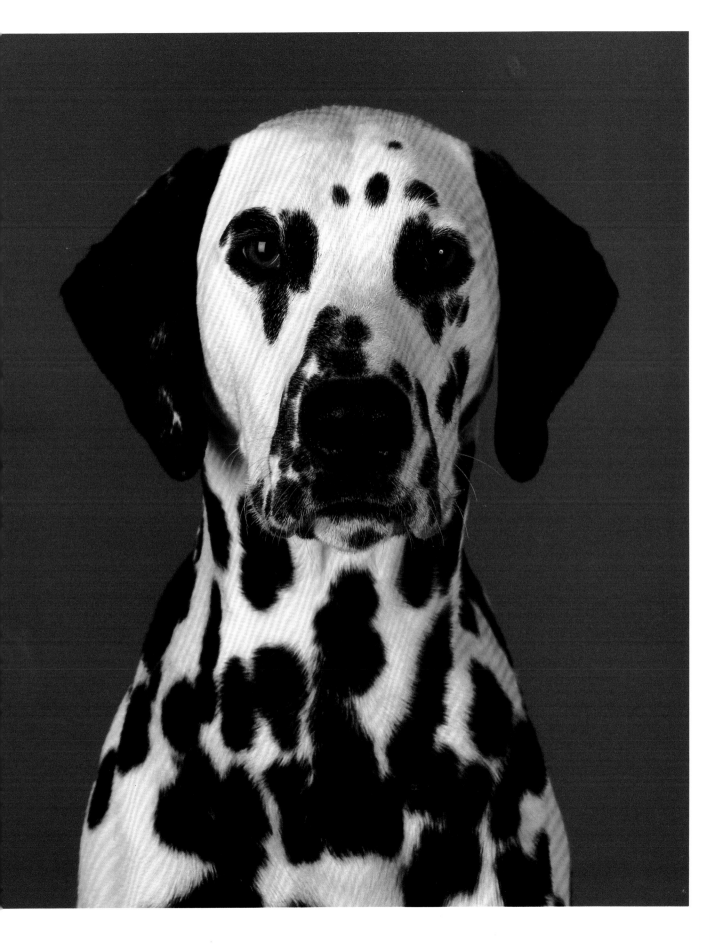

Ron Jagger, 1981

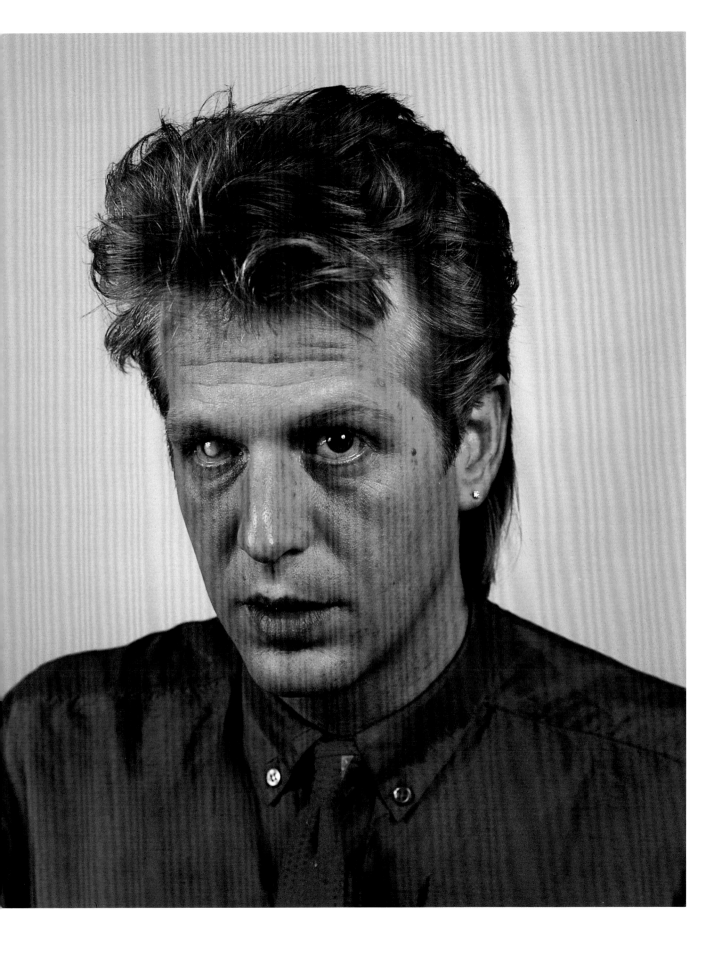

Menorah, 1990

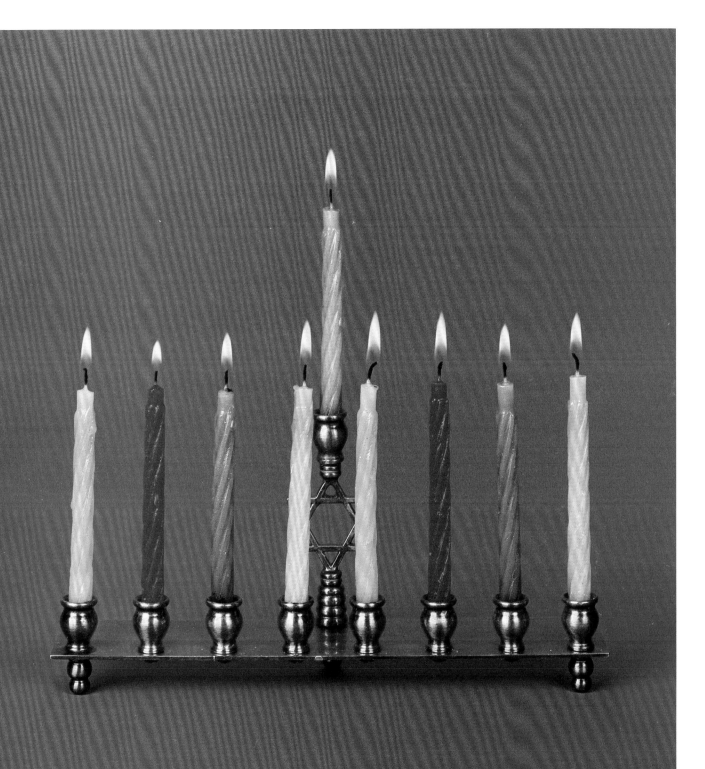

Glass of Water, 1990

following pages: Nila Ohuferko, 1982; John Hayes, 1984

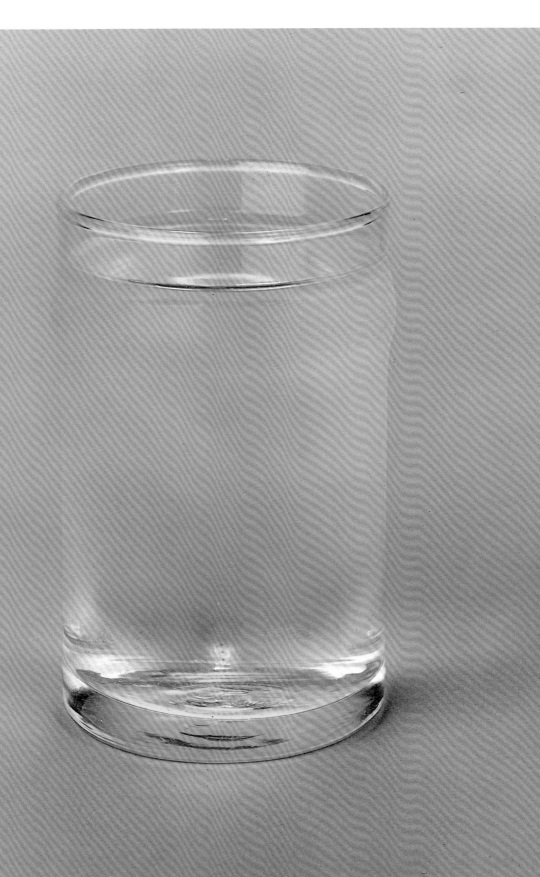

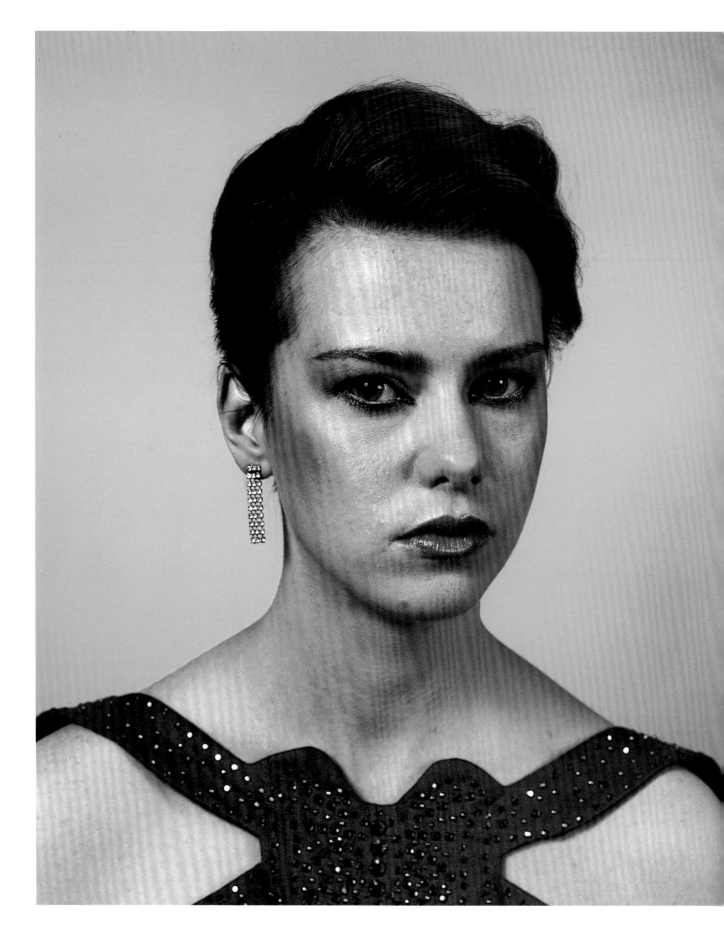

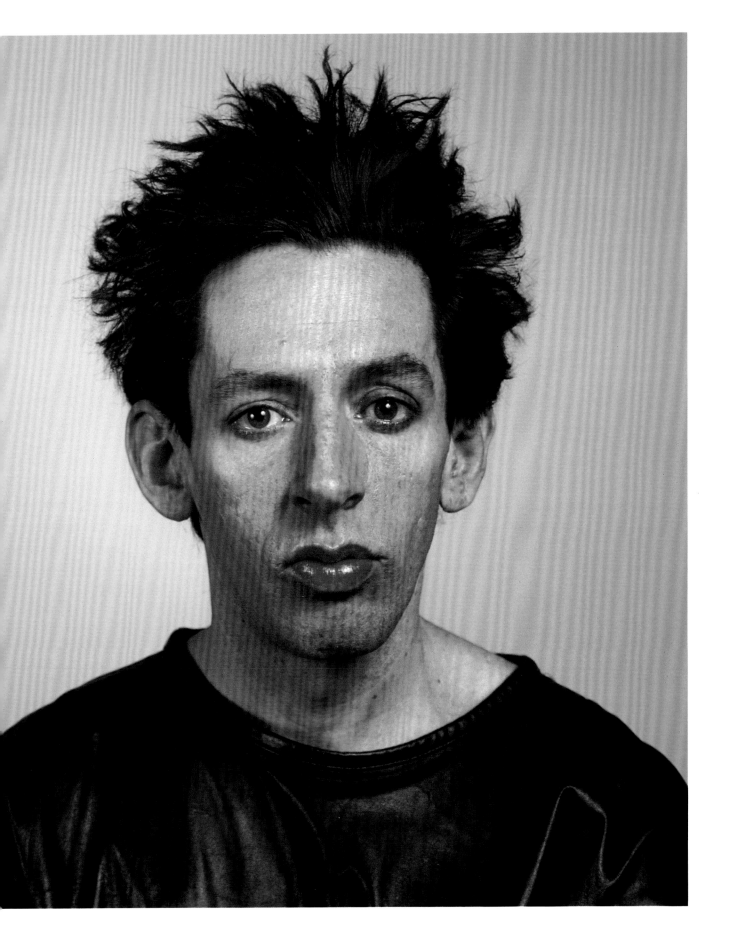

Archie, 1992

following pages: Truck, 1990; Flag, 1990

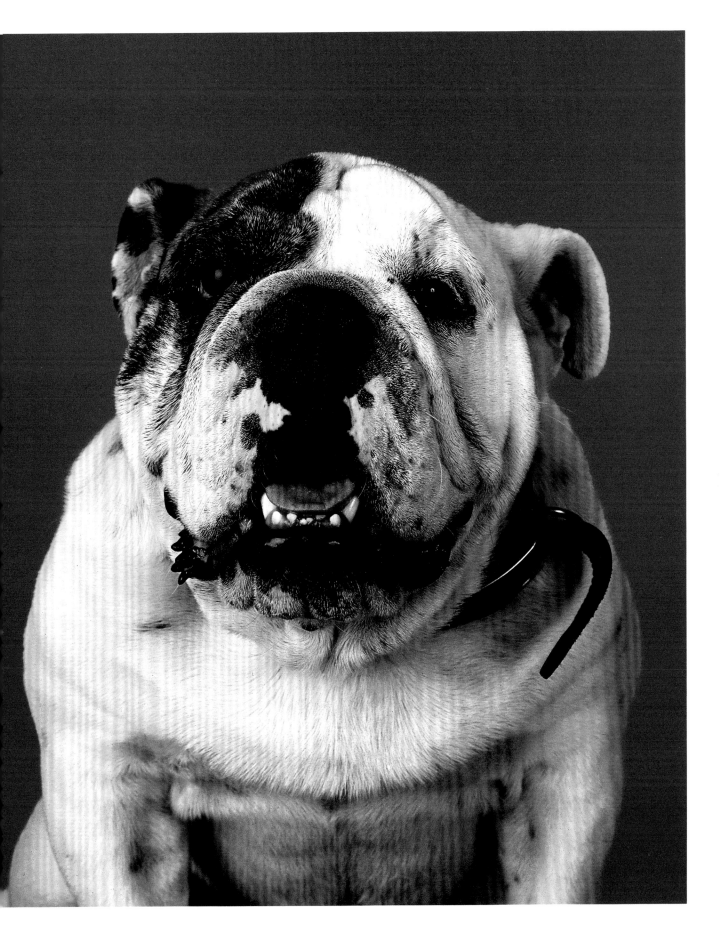

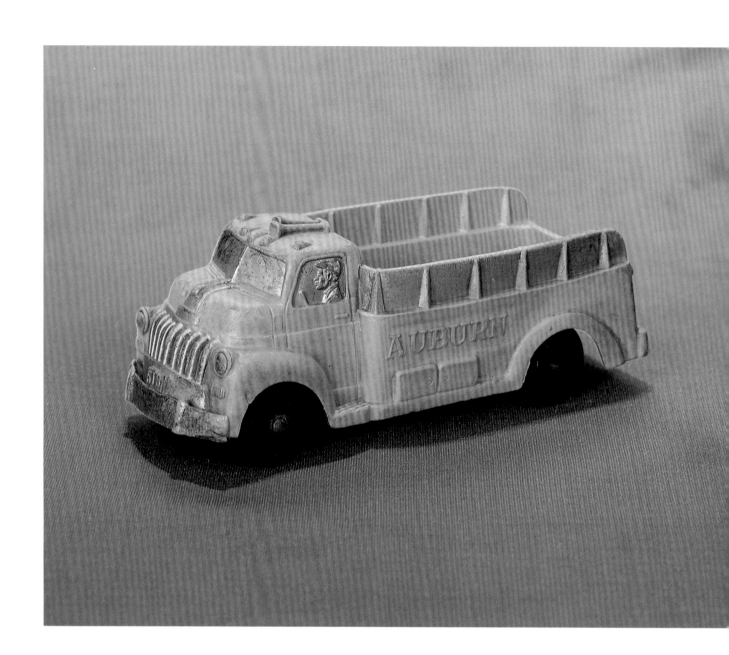

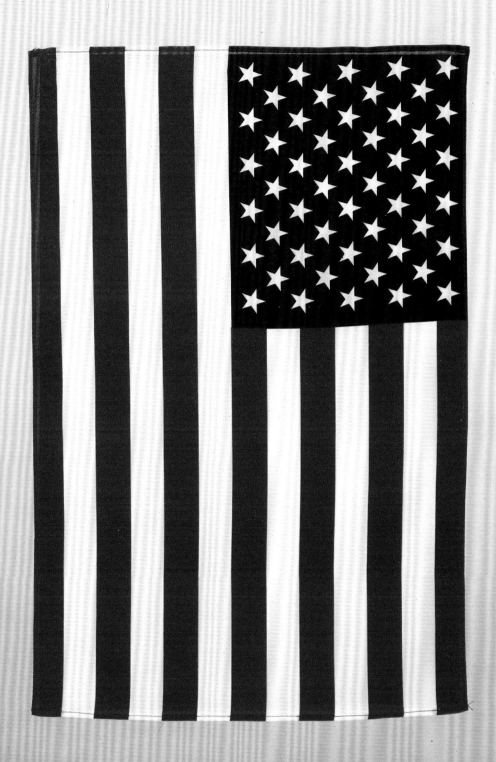

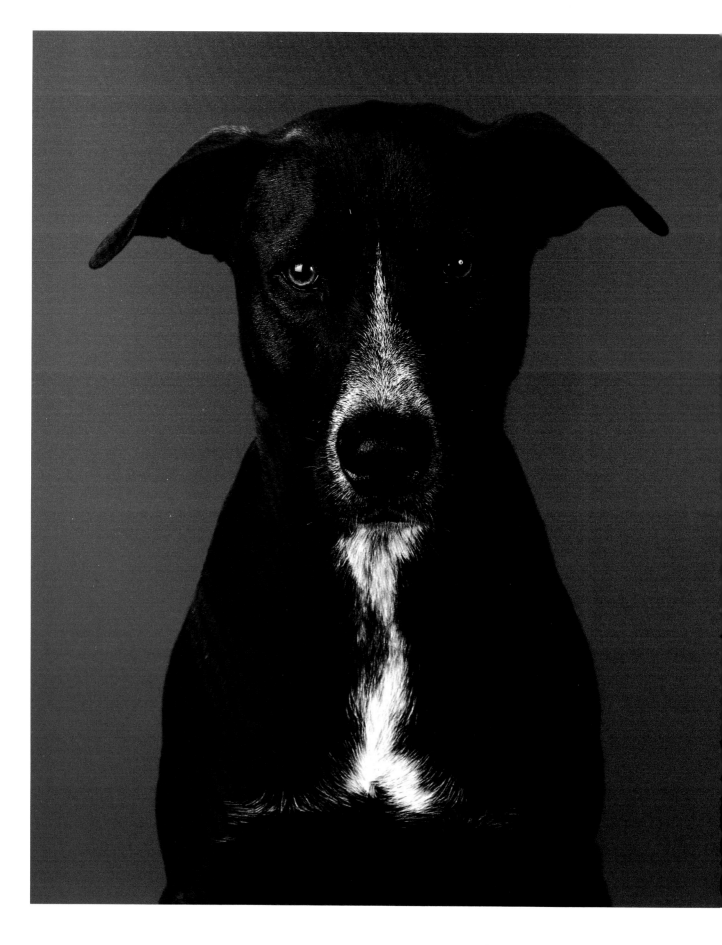

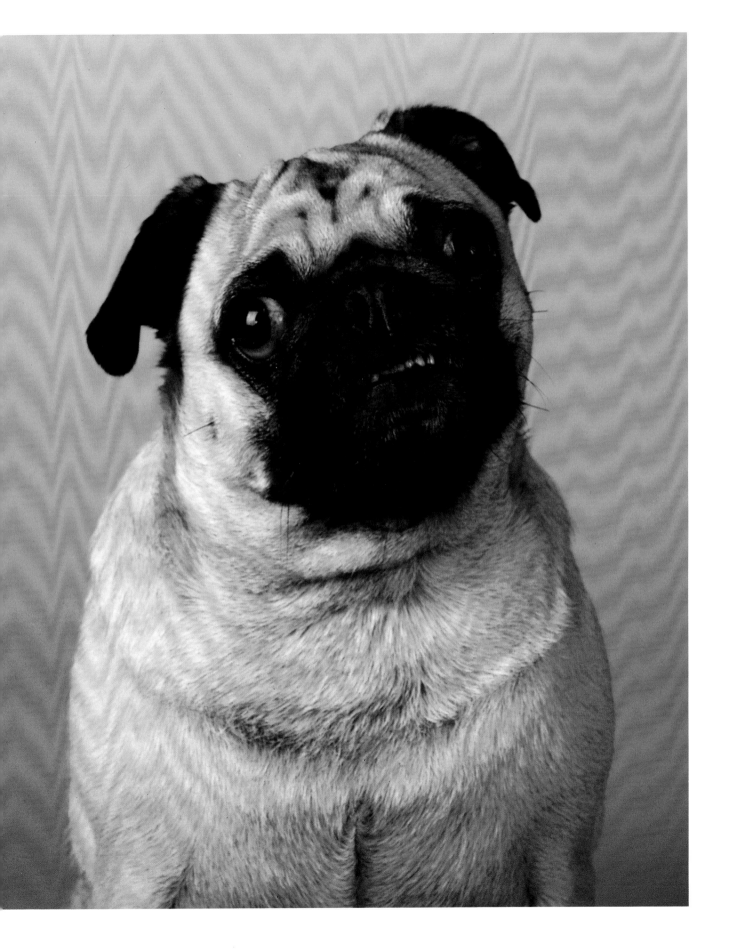

preceding pages: Merlin, 1992; Mimi, 1992

Zorba, 1990

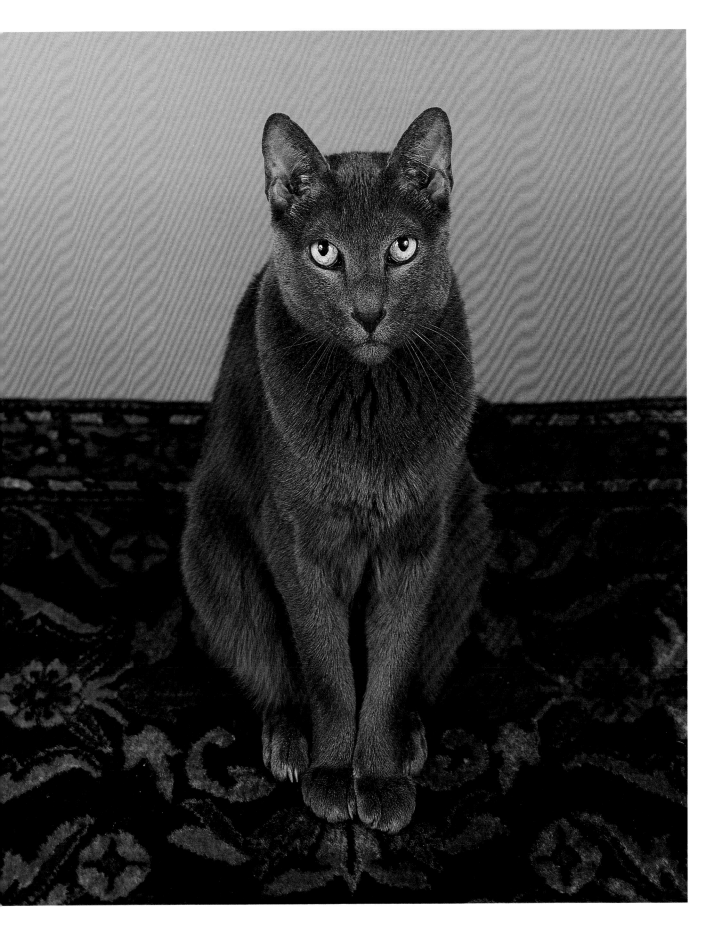

Chef's Knife, 1990

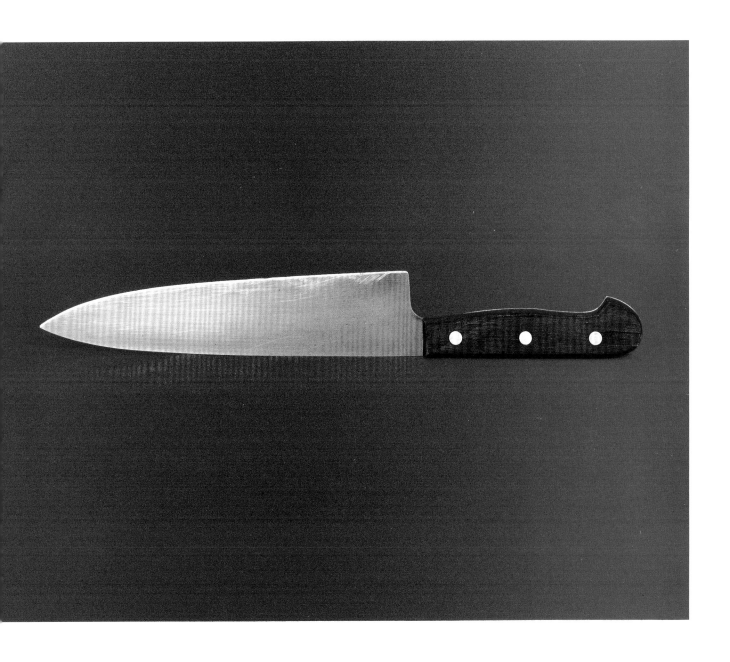

French Fries, 1992

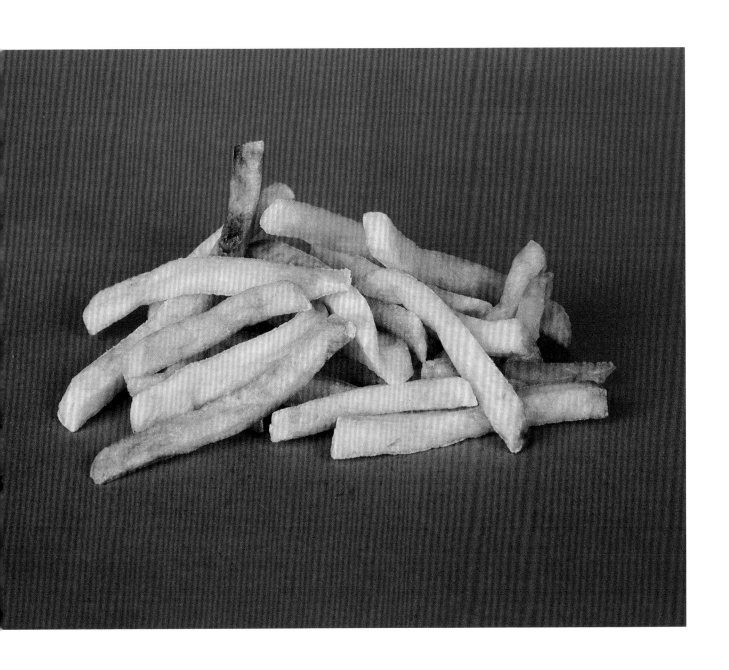

Cindy Sherman, 1985

following pages: Animal Crackers, 1990; Football, 1990

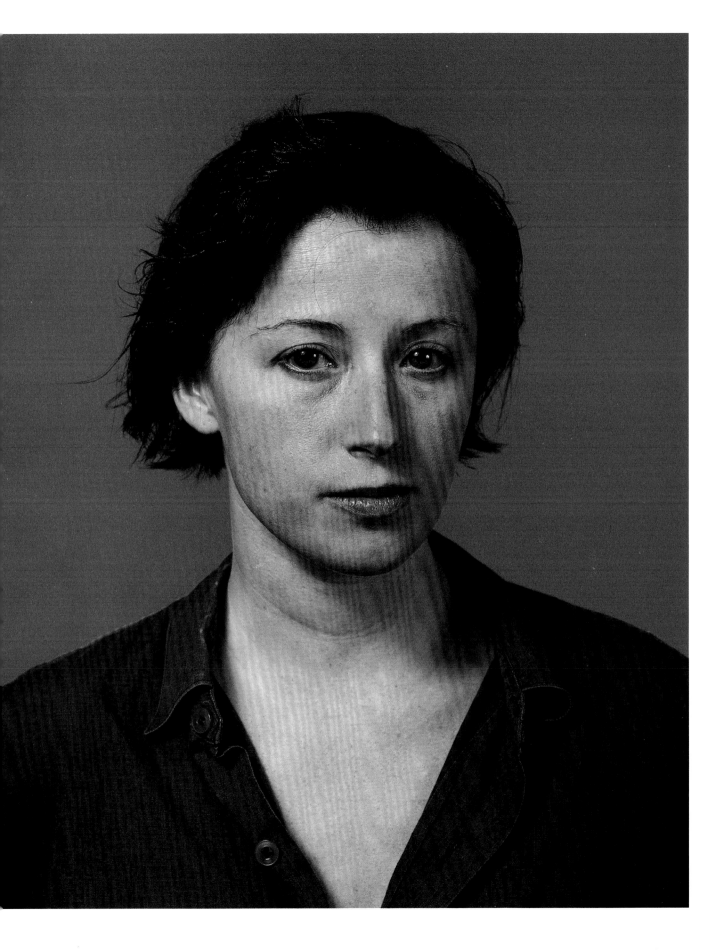

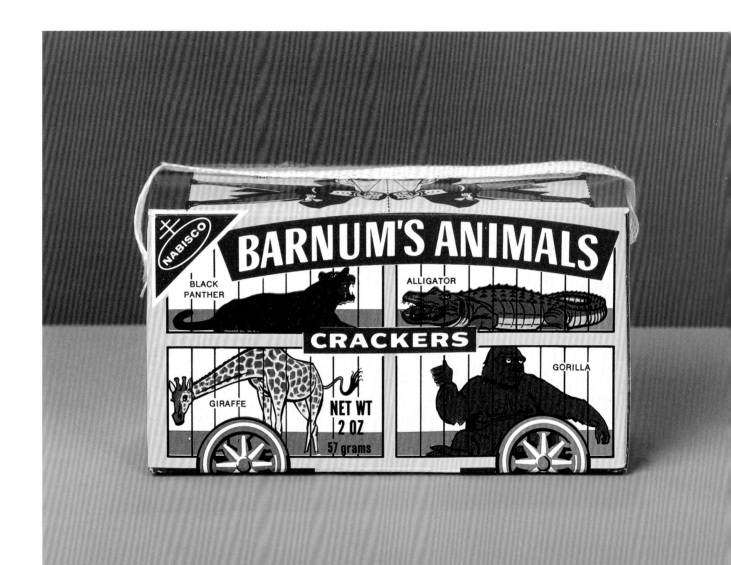

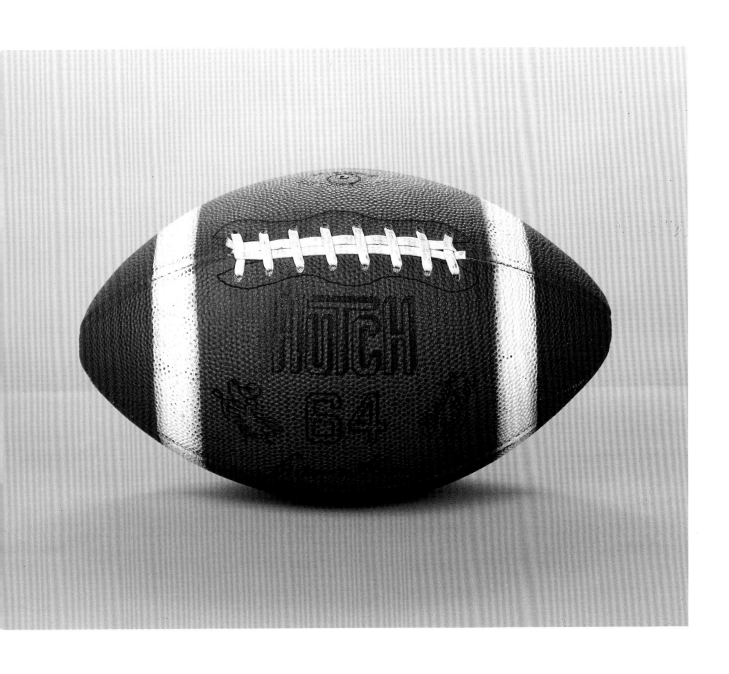

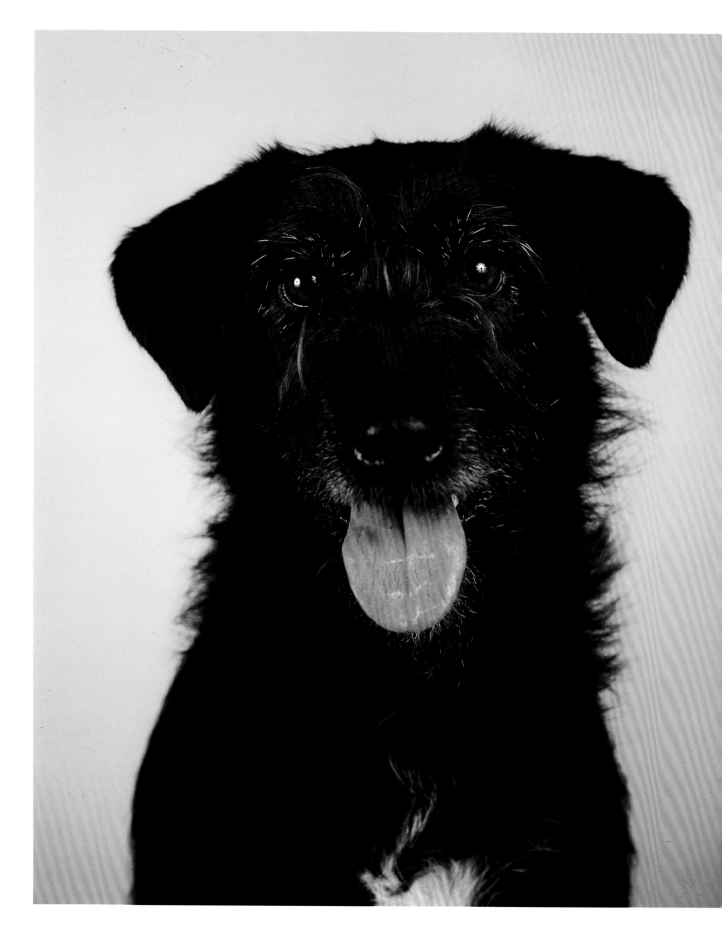

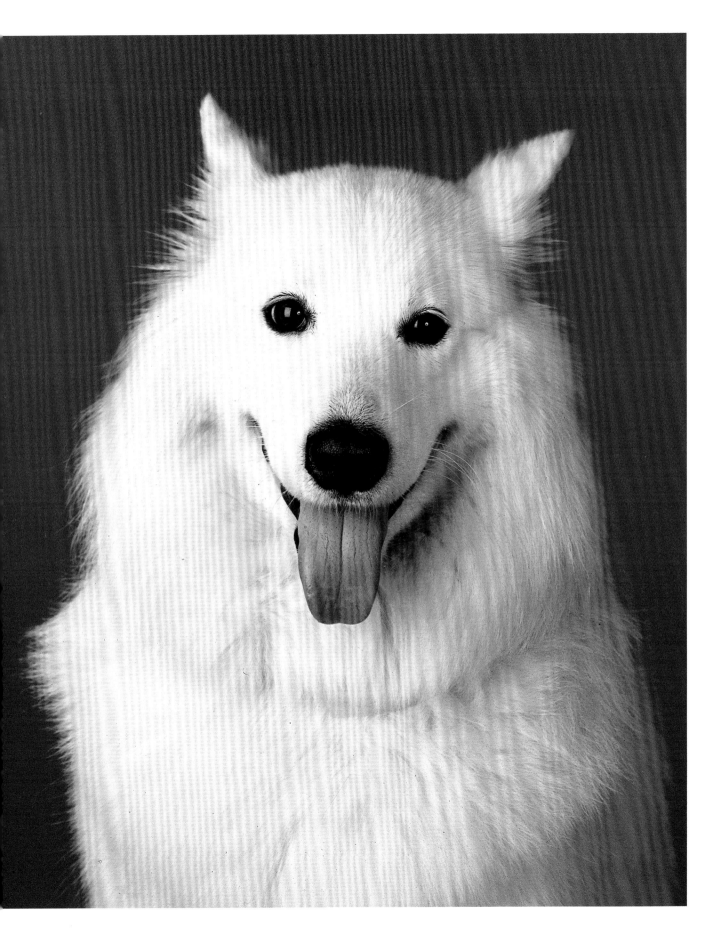

preceding pages: Clara the Dog, 1986; Samantha, 1992

Wally, 1992

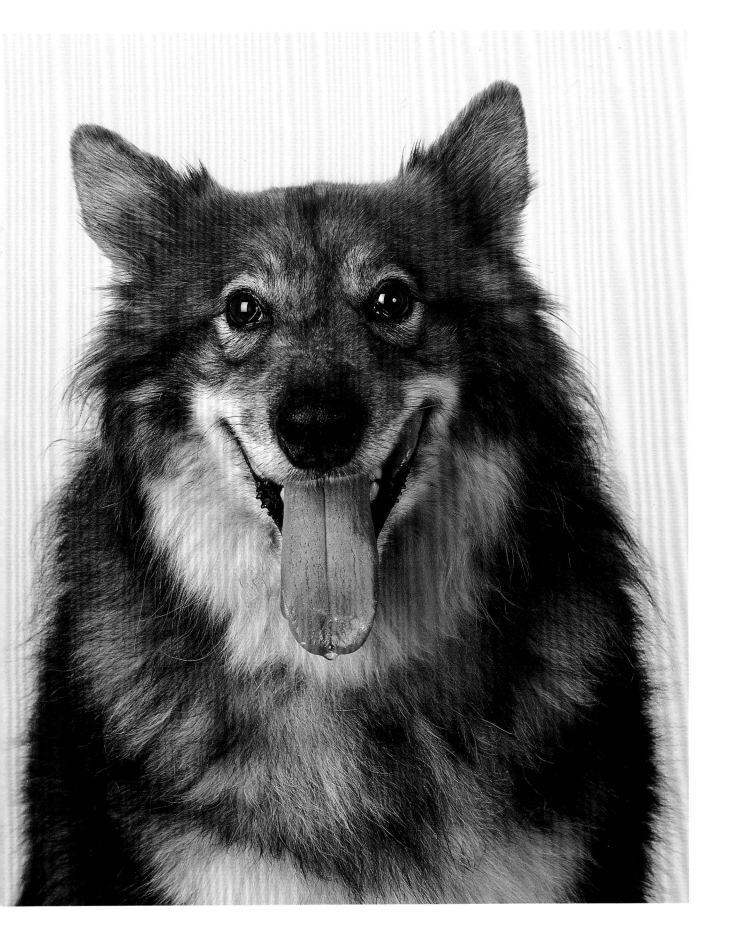

Egg, 1990

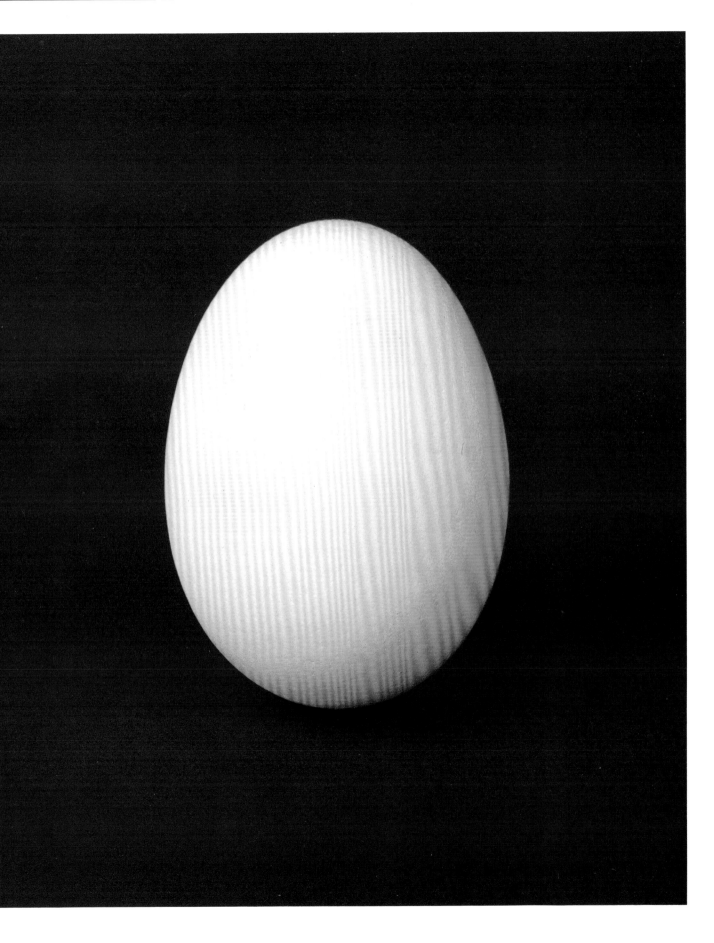

Neil Winokur

Neil Winokur is an archetypal urban specimen, late twentieth-century model. Born in Queens, New York, in 1945; educated in city public schools and at the Bronx campus of Hunter College (where he got his BA in 1967 with a major in math and physics), Winokur has lived in New York nearly all his life save for the requisite hippy year (1971 in his case) in San Francisco. "I function best here," he says. "I've never lived in the country; I think I'd be a fish out of water." After college, in between working at a draft-deferred job at a Lockheed plant in New Jersey, and briefly at New York City's Department of Social Services as a social worker, Winokur began making photographs with a roommate's Pentax. "That movie *Blow-Up* was big," he remembers, "and everybody thought, Oh, I'll be a photojournalist. But I never thought that I'd be a photographer."

And for several years he wasn't, except in the most offhand way. But early in the seventies, Winokur, who had begun experimenting with black-and-white street photography, set up his own darkroom. He's been working off and on at New York's legendary second-hand book-store, the Strand, when he got a job in the darkroom of a Soho photographer who specialized in pictures of art and gallery installations. It was here Winokur first learned to operate a large view camera and to develop and print professionally in black and white. But working all day on other photographer's prints (including those of Robert Mapplethorpe early in his career) usually left Winokur too drained to pursue his own work, so he returned to the Strand (where he's currently one of its top managers), bought his own 4x5 view camera, and launched his first color project at the beginning of the eighties.

Because his superglossy, color-saturated, frankly descriptive, coolly deadpan, life-sized head shots were like no one else's, Winokur landed in key group shows very early in his career, notably a 1982 German roundup of contemporary portrait work called "Lichtbildnisse" and the Grey Gallery's prescient "Faces Photographed" the same year, where he hung alongside Robert Mapplethorpe, Nan Goldin, Peter Hujar, Bruce Weber, John Coplans, and several significant others. Though four years passed before his first solo show, Winokur was hardly going unnoticed (the hip celebrity of many of his subjects—Andy Warhol, Cindy Sherman, Holly Solomon, Philip Glass, and Mary Boone among them—didn't hurt). He was in eighteen group shows in the intervening years, including a number of important international surveys that established the postmodern critique of the psychological portrait.

By the time Barbara Toll mounted his first New York solo show in 1986, Winokur was shoring up his portraits with equally straightforward, garishly colored pictures of objects chosen by his sitters to amplify, however imperfectly, their identity. Framing each image separately, he'd arrange them in various configurations (a cross, a pyramid, a box) he called "totems" or as horizontal triptychs that flanked a large, full-length seated portrait with panels of objects, like classic altarpieces. In one series, which Winokur describes as salon-style portraits, the subject was seated surrounded by favorite possessions in the same large frame, suggesting an Egyptian prepared for immediate entombment.

The careful attention Winokur devoted to his individual pictures of people's possessions resulted, inevitably, in a 1990 show devoted only to huge pictures of objects, a number of which are reproduced here: the glass of water, the high-heeled shoe, the egg. Many more of the still lifes in this book come from another, simultaneous 1990 installation Winokur did at Janet Borden's New York gallery called "Self-Portrait." Forty identically shaped and framed photos—from a teddy bear and a lit menorah to a dog-eared copy of *On the Road* and a hash pipe—added up to a witty portrait of the artist and, by extension, his generation. Twenty of the elements in "Self-Portrait," including Winokur's pictures of himself, his wife, and his cat, were given a wall to themselves at the Museum of Modern Art's baby-boomers-come-of-age show, "Pleasures and Terrors of Domestic Comfort."

One of Winokur's cleverest early "totems" involved a dog and its possessions (a bone, a rubber toy, a box of liver treats, a tennis ball), so his 1992 show of dog photos wasn't entirely unexpected. But, as the many examples here show, Winokur's dog portraits are the emotional flip side of his people portraits. Bursting with an expressiveness and enthusiasm deliberately squelched in his human sitters, Winokur's dogs overturn his chilly pop formalism to expose it's undefended, playful side. With the dog pictures and a more recent installation designed as a memorial to a friend who died of AIDS, Winokur seems to be moving warily into more unrestrained and personal material. A repeated image from the memorial show—a small, burning candle on a rose-red background—neatly sums up grief, remembrance, and hope. Like so much else here, it's a sign that Winokur, the portraitist who continues to slyly subvert the genre, has also become a photographer of unexpectedly eloquent still lifes.

— Vince Aletti

Technical information

Though he began with an old Leica and, briefly, a Nikon, for at least ten years Winokur has used a 4x5 view camera made by Toyo and outfitted with a German-made Schneider lens for all his color studio work. That studio, for many years a rented space in the Soho area, is now in his own lower Manhattan loft. He lights his subjects with two sets of strobes—in front and in back—to give them a surrealistic glaze that's only diffused a bit by the glow from a soft light box. Most of Winokur's early portraits (the Warhol shot here is one example) were taken against white seamless backdrops that he bathed with color from gel-covered strobes. When that effect proved insufficiently jarring and intense, he switched to color filters plus the brightly colored seamless paper whose acid greens, power blues, and tart cerises have become his trademark. Printing his images as Cibachromes highlights the subjects' unnaturalistic sheen and skews the color into a slightly artificial, metallic range. "It's the difference between using oil paints and acrylics." Winokur says. "Cibachrome is like acrylic. This is *almost* a green. I like that."